Rousseau

Rousseau

Edited by David Larkin
Picture research by Celestine Dars
With an introduction by Martin Greene

Ballantine Books
New York

We are most grateful to the galleries, private collectors
and museums who have kindly allowed the use of material
in their copyright.

Copyright 1975 in all countries of the International
Copyright Union by Random House, Inc.

All rights reserved.

ISBN 345-24476-1-595

First Printing: April, 1975

Printed in Italy by Mondadori, Verona

This edition published by Ballantine Books,
A Division of Random House, Inc.
201 East 50th Street, New York, N.Y. 10022
Simultaneously published by
Ballantine Books, Ltd., Toronto, Canada

Henri Rousseau, a sometime solicitor's clerk and ex-soldier, retired at the age of forty-one on a small pension from the Customs department, to devote himself to the art of painting and to the greater glory of France.

He was a *petit bourgeois* at heart, diligent and uncritical of the order of things. He worked alone, 'with only nature as a teacher and some advice received from Gérôme and Clément' — two respected academic artists of the day.

Rousseau's first dated painting was executed five years before his retirement from the Customs; after this short apprenticeship and only a year as a full-time 'artist-painter,' as he styled himself, he exhibited his first painting at the Salon des Indépendants.

The Salon des Indépendants was formed by a group of disgruntled Impressionists and other painters,

partly to cock a snook at the academic establishment but also to enable any painter, without having to submit his work to a jury of dullards, to show his paintings alongside those of his contemporaries. It was a happy accident for Rousseau to fall in with these *indépendants*, although his bourgeois inclinations were in effect directly opposed to those of the Impressionists.

Rousseau's early work, in common with that of most primitive painters, was concerned with the real, the actual; portraits and paintings of animals and 'things.' He would take the dimensions of a sitter with a tailor's tape-measure in his effort to get the correct shape and size. It was shortly after first exhibiting at the Salon des Indépendants that he painted

Myself and first made the acquaintance of Gauguin, Redon, Gustave Coquist, Seurat and Pissarro.

Rousseau became known familiarly to his fellow artists as '*le Douanier*,' although he had never been a Customs officer but merely a minor inspector in a toll office. It was a title he did not deny, having as a soldier reached the rank of sergeant in the Franco-Prussian war, and being a lover of pomp, titles, and medals, in the tradition of his bourgeois background.

On his retirement from the Customs and the commencement of his chosen career, he was a widower, his marriage to Clémence Boitard, who bore him numerous children — seven of whom died — ending in her early death. He

married again, one Rosalie-Joséphine Noury, with whom he was well contented, until her untimely death of cancer only four years later, in 1905. His private life, apart from the poverty ever-attendant on an itinerant painter, was smooth and comfortable — unlike the lives of his contemporary artists.

Two crucial meetings in his life affected not only Rousseau, but the lives of those whom he met. These were with the poet Guillaume Apollinaire, who celebrated Rousseau in his verse and whom Rousseau painted; and with Alfred Jarry, the bohemian author of *Ubu Roi*.

Rousseau and Jarry met in 1893 at the Salon des Indépendants in front of a painting called *The Earthly Paradise*. 'Does the picture please you?'

Rousseau asked Jarry. 'It is absolutely sublime,' answered Jarry; 'but who are you?' 'Henri Rousseau, the man who painted it.'

Jarry acted as a catalyst. He immediately commissioned Rousseau to paint his portrait — a portrait he used for target practice, only his head finally surviving on the canvas. Alfred Jarry was a native of Rousseau's home town, Laval; he was a midget of a man who lived in a room to measure. He gave Rousseau an intellectual existence and integrated him into a world of artists, a world that Rousseau could only have dreamed about. Unlike many of the other painters, such as Gauguin, who played merciless practical jokes on the apparently naïve Rousseau, Jarry befriended him in a practical way by giving him shelter in the

Boulevard de Port-Royal when he had the bailiffs on his heels. Alfred Jarry's regard for Rousseau's art was genuine, and he saw that he had his 'roots in himself' as he said, whereas his brother artists would have had him barred from the Salon des Indépendants, but for the intervention of Degas, who supported him.

Apart from their place of birth and their respective arts, Rousseau and Jarry had little in common with regard to their lives. Rousseau was kept on at school up to the age of nineteen, but failed to obtain his *baccalauréat*, being interested only in poetry and music. Dreamer though he was, he rose to the rank of sergeant in the army and lived a sober and industrious life. Jarry was thrown out of the army as an incorrigible bohemian, was alcoholic and syphilitic.

Regardless of his contemporaries' estimation of his work (the young sophisticates had dubbed his manner *le style concièrge*), Rousseau's attitude was that of a practical man. 'I have been told that my work is not of this century,' he said to André Dupont. 'As you will understand, I cannot now change my manner, which I have acquired as a result of obstinate toil.'

With such recognition as was accorded to Rousseau through his exhibiting at the Salon des Indépendants, his work broadened into more exotic fields than those normally associated with purely primitive or naïve art. He painted jungles, wild animals, lions, tigers and monkeys. There was a legend that Rousseau had gone to Mexico in the French army sent by Napoleon III to aid Maximilian,

where he was supposed to have acquired first-hand knowledge of these exotic jungle backgrounds. There was no foundation for this legend, though he had been in the army at that time. It was well known among his acquaintances, however, that at this period he made numerous trips to the Paris zoo and botanical gardens.

Regardless of his source of inspiration, with its roots in himself, his work rises above the insults and practical jokes he suffered. Gauguin sent Rousseau an invitation from the President of the Republic to a lunch at the Élysée Palace. Rousseau, needless to say, was turned away at the door. On being asked how he got on, he replied quite correctly that he had been turned away at the door because he was not properly dressed, though the President himself came to the door to assure him that he would be asked again.

Picasso, who became an admirer of Rousseau after buying an early portrait of his, *Mlle M.*, for a few francs in a junk-shop, gave a 'fantastic' banquet in his honour at his own studios in the Rue Ravignan, specially decorated for the occasion. The guests, who included Leo and Gertrude Stein, Georges Braque, Marie Laurencin, Guillaume Apollinaire and Max Weber, met first at a nearby café and were already well primed on arrival. The enjoyment of the evening was not spoiled by lack of food, despite Picasso's having given the caterer a date two days after the event. Extravagant speeches and toasts were

made, and Apollinaire improvised a poem, beginning 'You remember, Rousseau, the Aztec Landscape,' harping back again to his non-visit to Mexico. Rousseau, who played his violin for the assembled guests, was so overcome with emotion that tears ran down his cheeks.

In the last years of his life Rousseau came into his own as a painter. Max Weber recalled Rousseau's appearance at the elder Madame Delaunay's salon: 'a small, modest figure, with a sweet piping voice and the simplicity of a child. This was the man who represented in the flesh what the young sophisticates had named *le style concièrge.'*

It was the fullest period of his life. The dream had come true. He found himself at the center of the most advanced group of artists and writers in Paris, admired and recognized by the intellectual world. He even went so far as to acquire a dealer, Joseph Brummer, though his financial worries were by no means over, as he told Apollinaire in 1914: 'Having my rent to pay, then a big bill at my color merchants, I am very short of money, and this evening I have only fifteen centimes for supper.'

Flourishing though his artistic affairs were, his naïveté had led him into trouble with the law. This was through an ex-music student of his and here it must be remembered that Rousseau thoughout his career as a painter not only took in music pupils but gave *'soirées toutes familiales et artistiques'* which were attended by his friends and neighbors and also by such

eminent artists as Picasso, Delaunay, Duhamel, Apollinaire, Jules Romains, Max Jacob, René Arcos, Braque, André Salmon, Soffici, Albane, Marie Laurencin; eminent visitors from abroad and also *'les demoiselles de son quartier.'* The student in question had devised a complicated fiddle on the Banque de France employing a number of different names and poste-restante addresses. Rousseau foolishly not only lent himself to the scheme, but also used his own name, which gave the police no difficulty in tracing him. In spite of eloquent pleas on his behalf by his legal representative, offering Rousseau's naïveté as a defense, he was found guilty and held over for sentence. He wrote numerous letters from the cells offering his paintings by way of expiation. After being given a two years' suspended sentence — his age and service to the nation being taken into account — Rousseau said: 'I thank you deeply, Monsieur le Président; I will paint the portrait of your wife.'

Although Rousseau had almost reached his apotheosis as a painter, his worldly troubles were not yet over. When his second wife died, ending their short-lived marriage, he fell madly in love with a widow ten years younger than himself, a Madame Léonie, on whom he squandered such money as he had. She was, like himself, of the *petite bourgeoisie*, and at first encouraged Rousseau in his hopes, Her family, however, took a dim view of this recently convicted felon and painter, and Léonie, who held a job in a department store, severed relations with him. Rousseau was a romantic, as a painter and in life, and he took

his dismissal seriously. He went away broken-hearted and returned later with a self-inflicted wound in his leg. The wound became gangrenous and Rousseau died in a Paris hospital on 4 September 1910 at the age of 66.

Among those as his funeral was Paul Signac, president of the Salon des Indépendants. A year later a tombstone was erected by Robert Delaunay, Apollinaire and M. Quival, his landlord. In 1913 Brancusi and the painter Ortiz de Zarate engraved on the stone

Apollinaire's epitaph:

Hear us kindly Rousseau
We greet you.
Delaunay, his wife, Monsieur Quival and I
Let our baggage through the customs to
 the sky,
We bring you canvas, brush and paint
 of ours,
During eternal leisure, radiant
As you once drew my portrait
You shall paint
The face of stars.

MARTIN GREEN

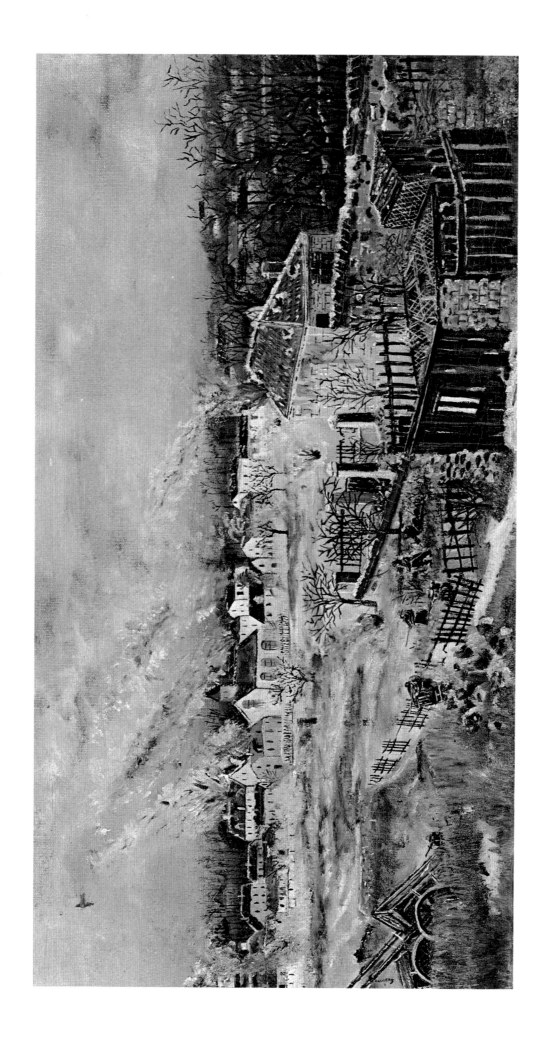

1) Episode de la Guerre de 1870
or La Bataille de Champigny
1882 $11\frac{1}{4} \times 19\frac{3}{4}''$

Musée d'Art Moderne, Paris
Photo – Bulloz

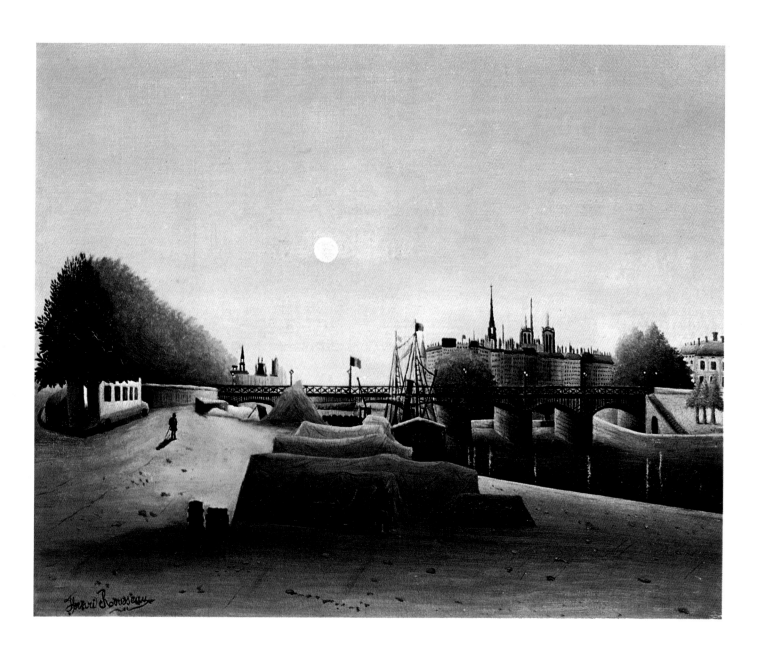

2) Vue de l'Ile Saint Louis

1888 $18\frac{3}{8} \times 22''$

Private Collection

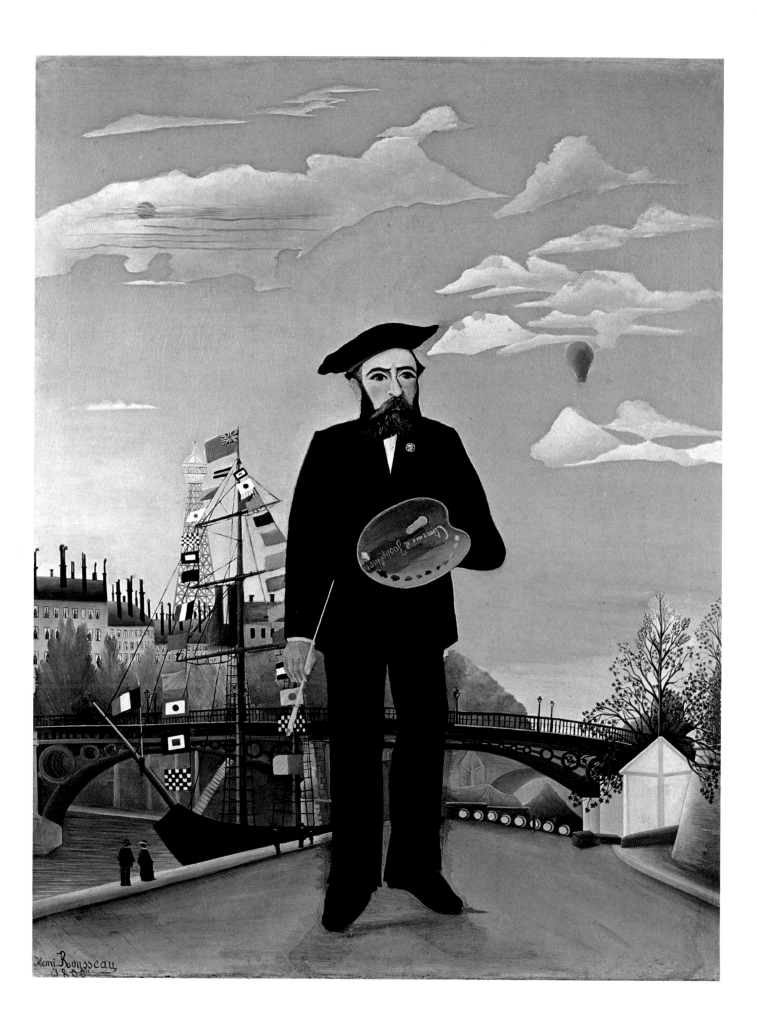

3) Self-portrait in a Landscape
1889–90 57¼ × 44¼″
Národni Gallerie, Prague
Photo – Held/Ziolo

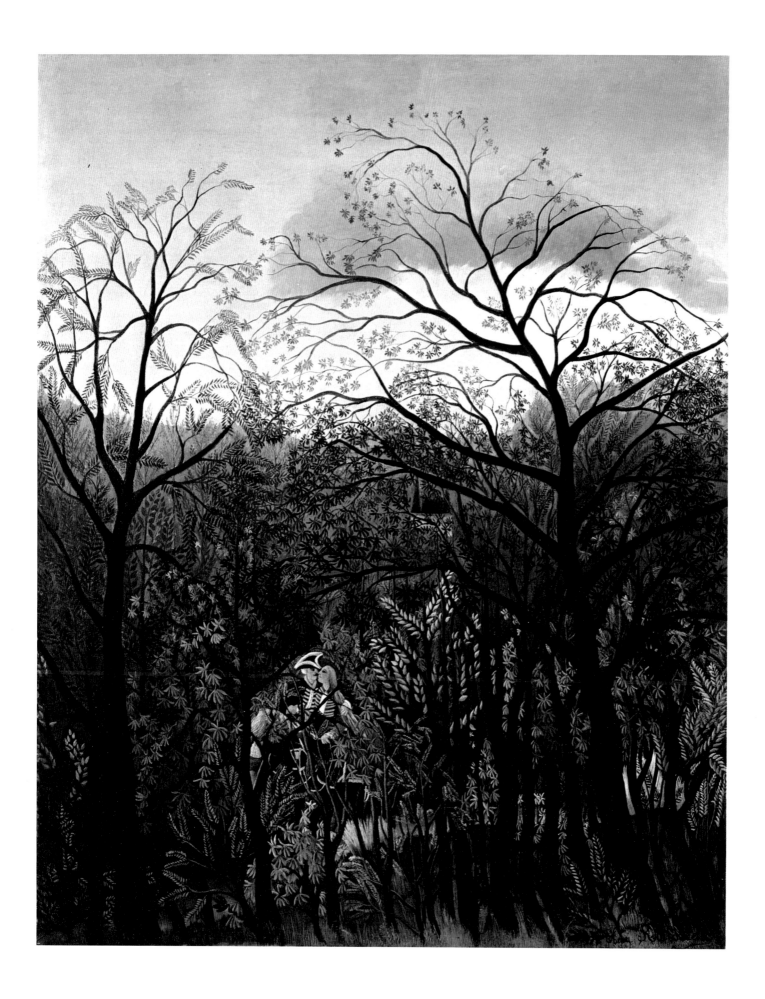

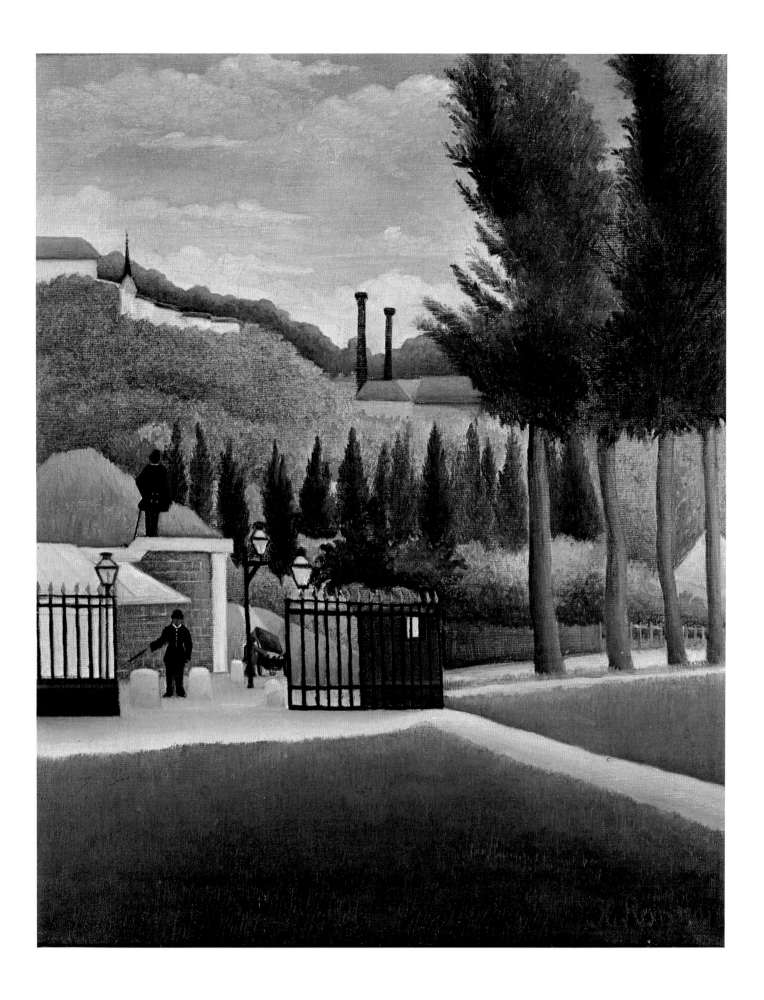

5) The customs Post at Vanves
1890 $16\frac{3}{8} \times 13\frac{1}{4}''$
Courtauld Institute, London

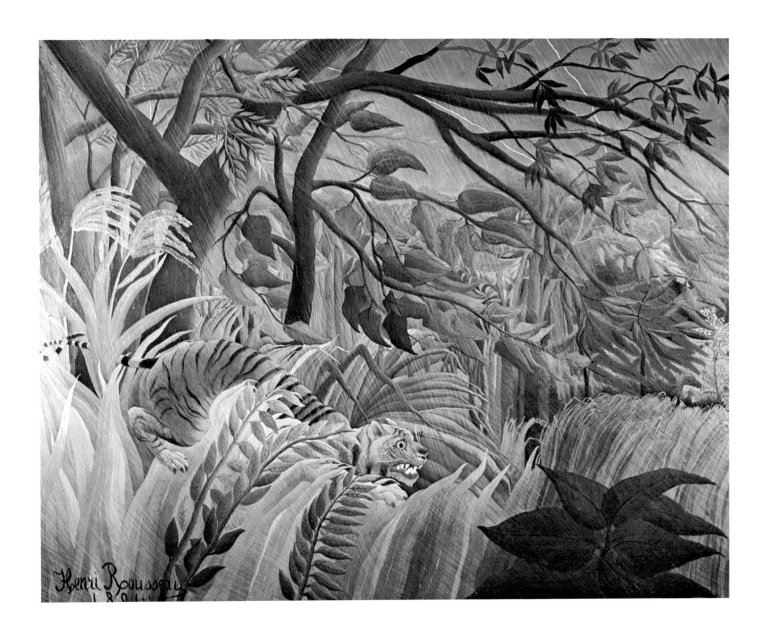

6) Tropical Storm with Tiger

1891 52 × 64¾″

National Gallery, London
Photo – M. Slingsby

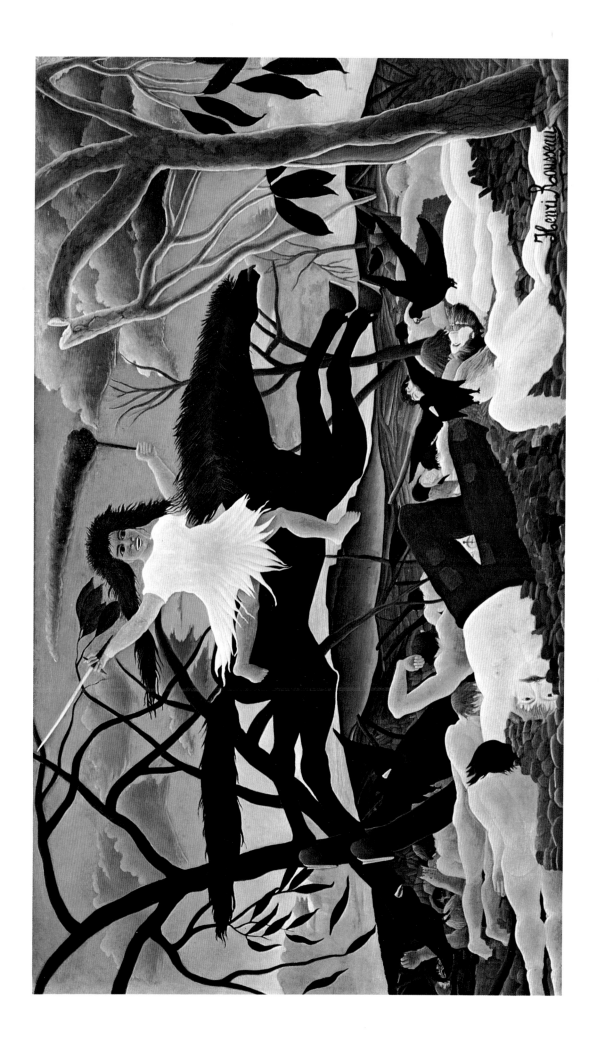

7) La Guerre

1894 45½ × 78″

Musée du Jeu de Paume, Paris
Photo – Josse/Ziolo

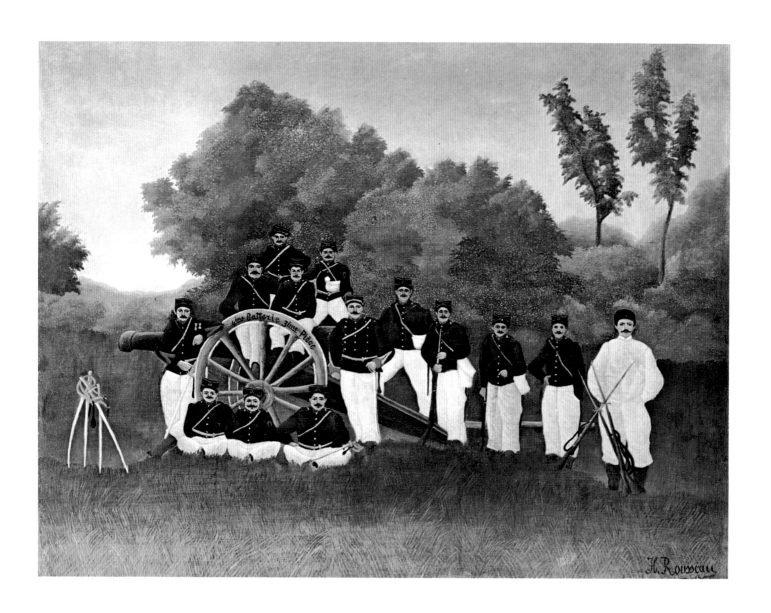

8) Artillerymen

1895 $28\frac{3}{4}\times36''$

The Solomon R. Guggenheim Museum, New York

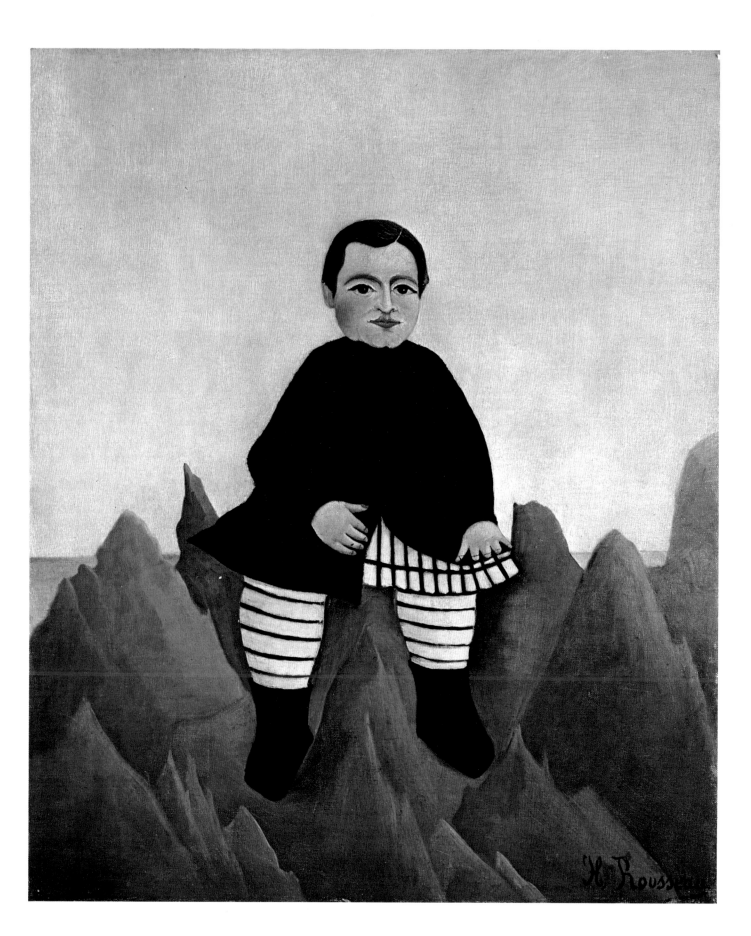

9) Child on Rocks
1895 22 × 18″
National Gallery, Washington

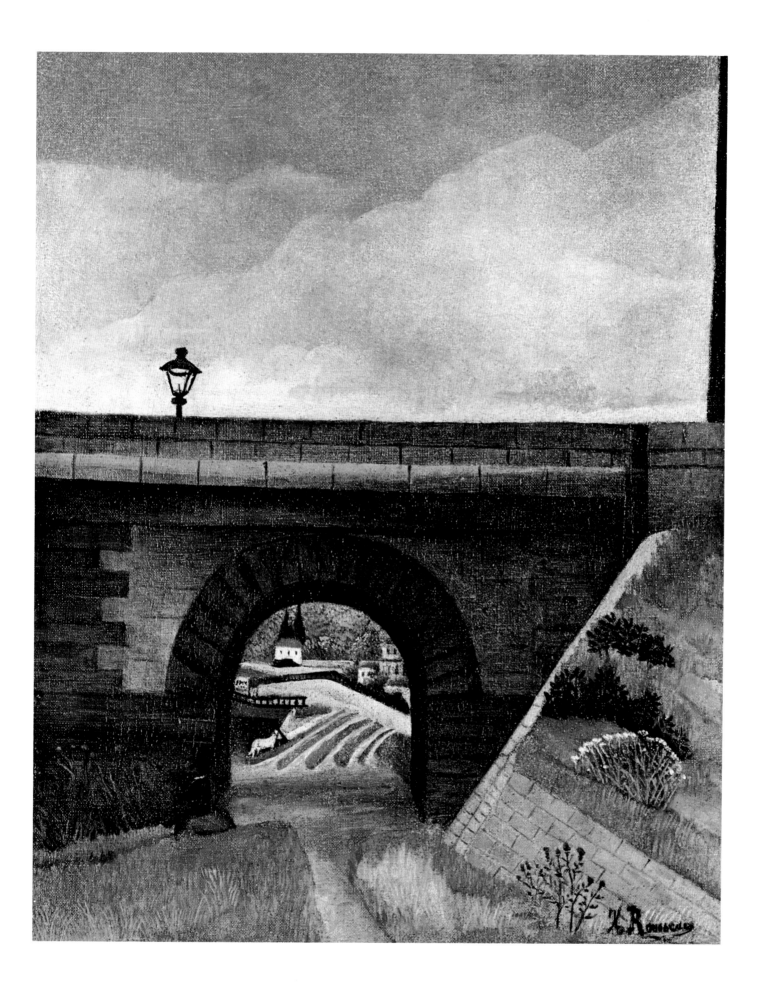

10) Bridge at Sèvres
c. 1895

Private Collection
Photo – Roland/Ziolo

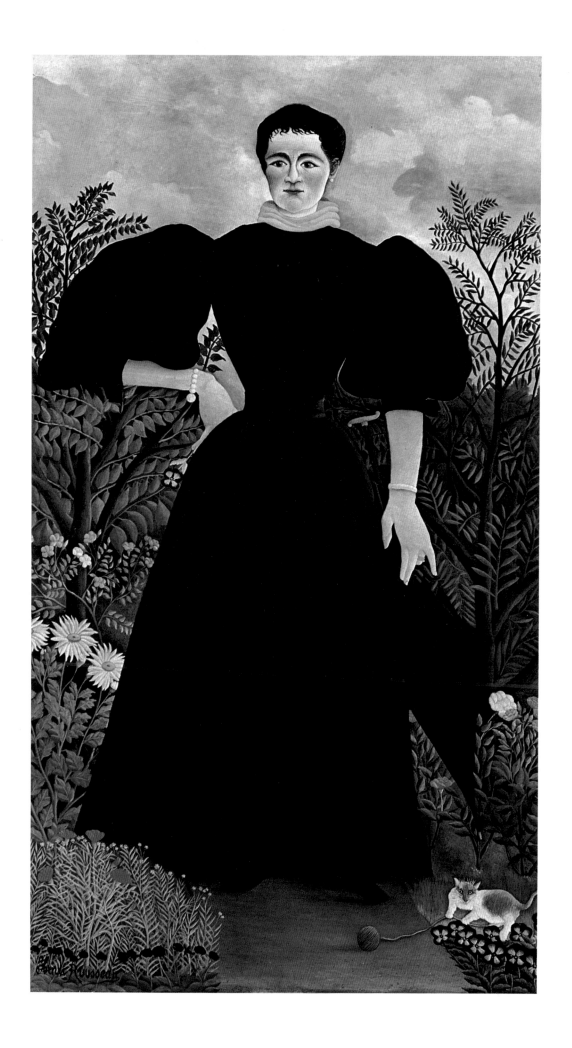

11) Portrait of his First Wife
1895–97 80 × 46″

Musée du Jeu de Paume, Paris
Photo – Held/Ziolo

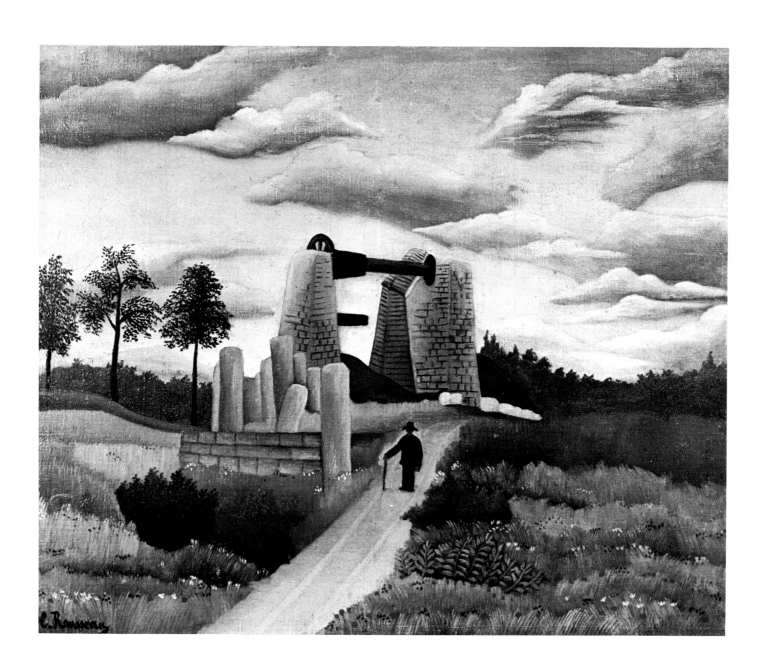

12) La Carrière
1896–97 19 × 22¼″
Private Collection, New York

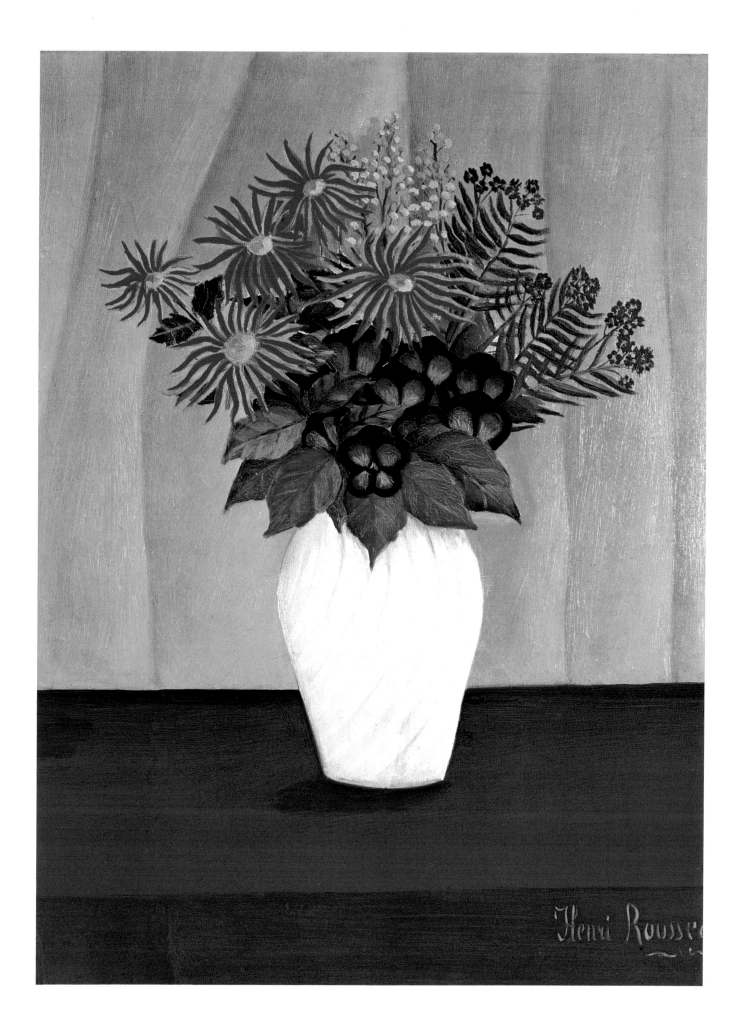

13) Flowers
1895–1900? $24\frac{3}{8} \times 20''$

Tate Gallery, London
Photo – Fleming

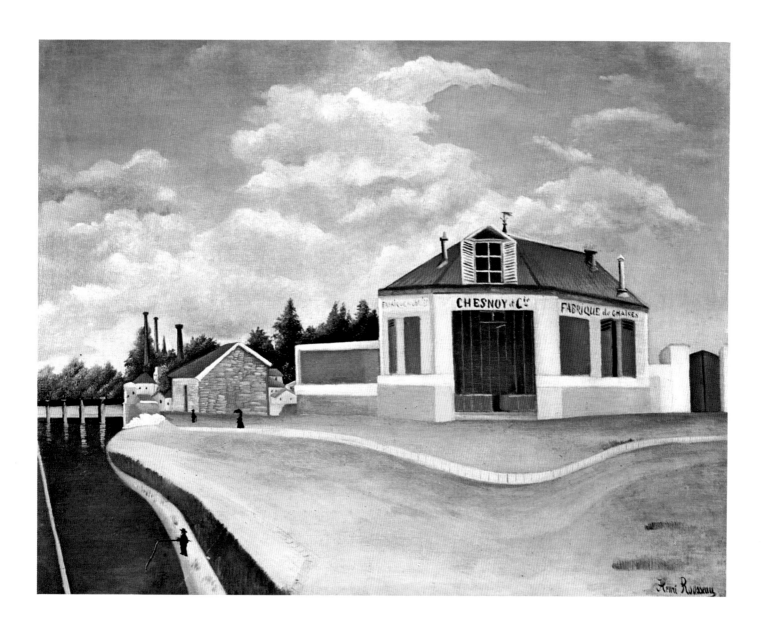

14) The Chair Factory
1897 $29\frac{1}{4} \times 36\frac{3}{4}''$

Collection Walter-Guillaume
Musées Nationaux, Paris
Photo – Roland/Ziolo

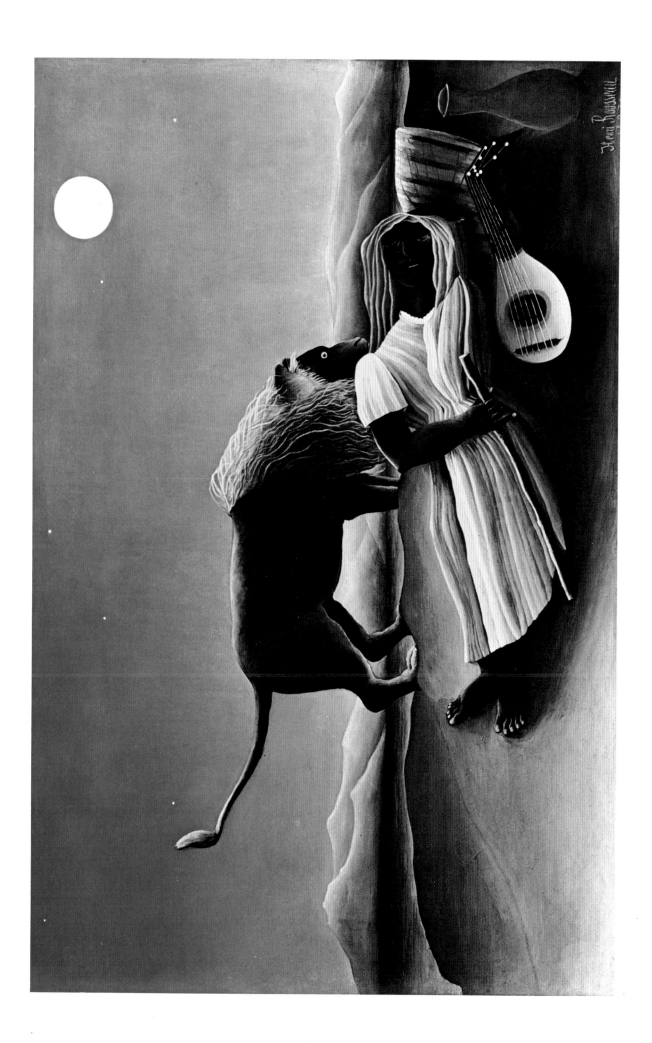

15) Gypsy Asleep
1897 51¾×80″
Museum of Modern Art, New York

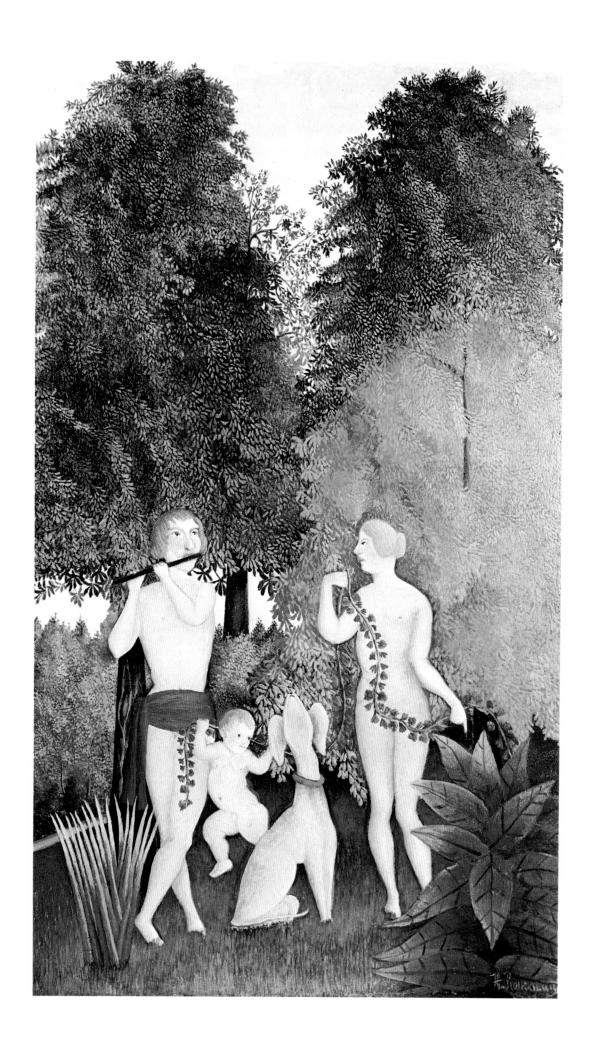

16) L'Heureux Quatuor
1902 $37\frac{1}{4} \times 22\frac{3}{4}''$
Private Collection, New York

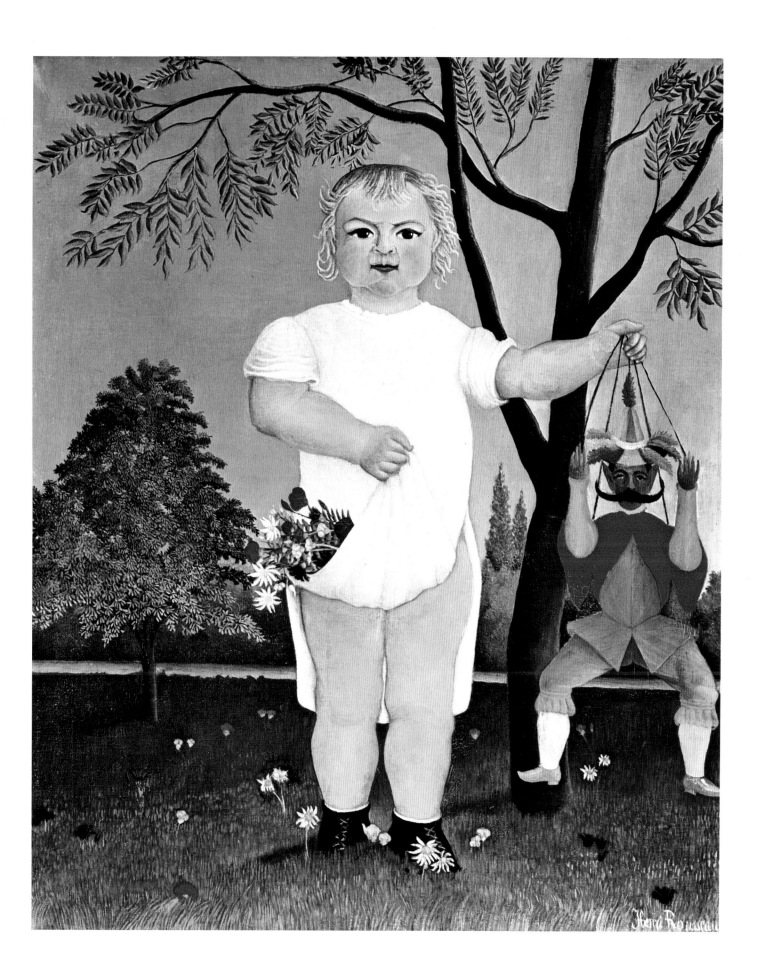

17) L'Enfant au Polichinelle
1903 $40\frac{3}{8} \times 32\frac{3}{8}''$

Kunstmuseum, Winterthur
Photo – Hinz

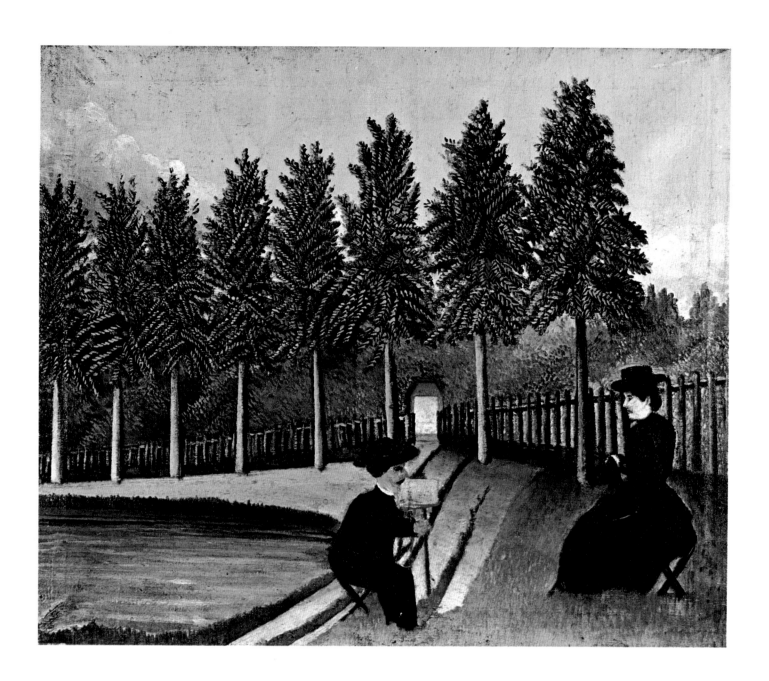

18) L'Artiste Peignant sa Femme
1900–05 $22\frac{3}{8} \times 26''$

Kandinsky Collection, Paris
Photo – Foliot/Images & Textes

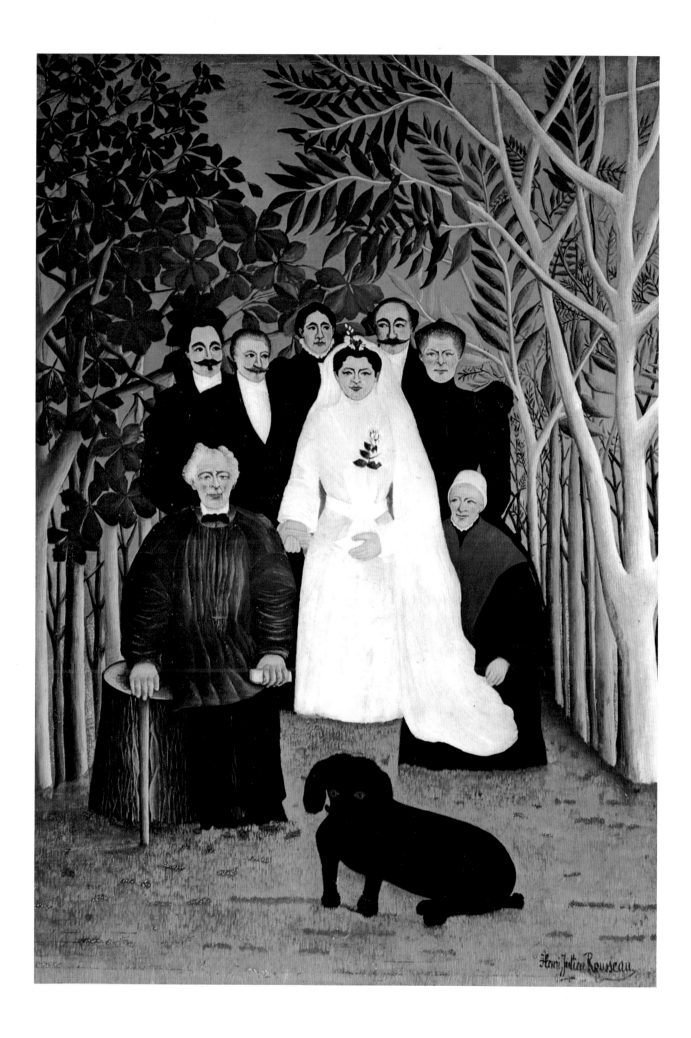

19) La Noce
1905 62¼×45½″

Collection Walter-Guillaume
Musées Nationaux, Paris
Photo – Foliot/Images & Textes

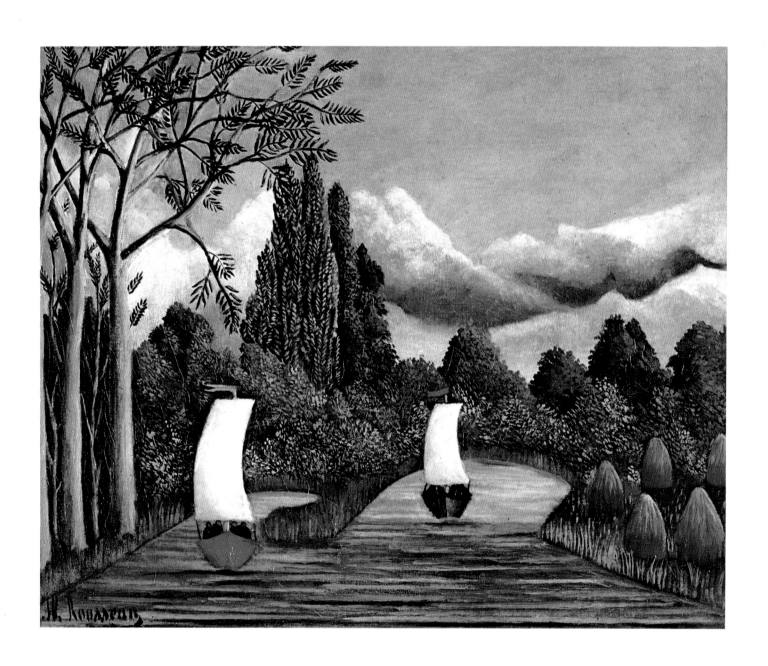

20) Bords de l'Oise

c. 1905 18 × 22″

Smith Collection, Northampton

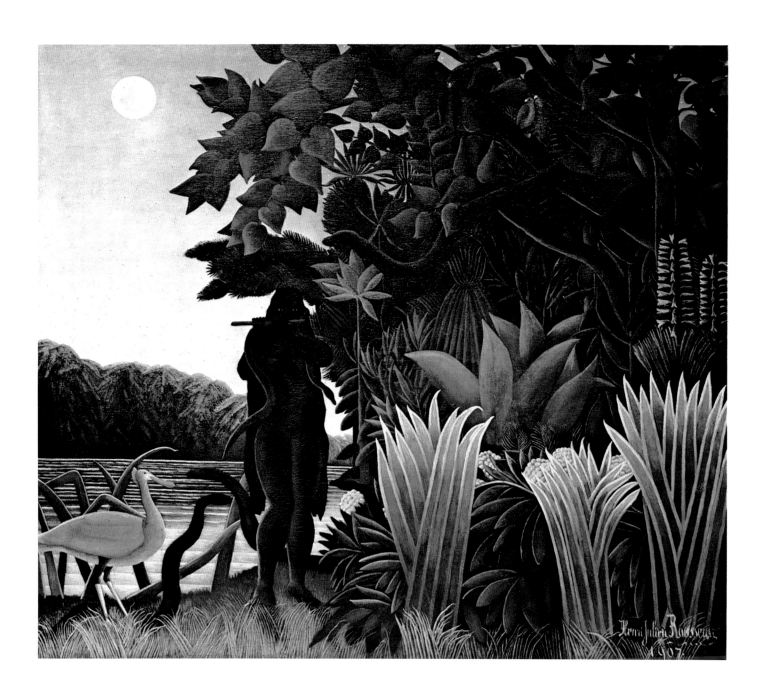

21) La Charmeuse de Serpents
1907 $67\frac{1}{2} \times 75\frac{1}{2}''$
Musée du Jeu de Paume, Paris
Photo – Josse/Ziolo

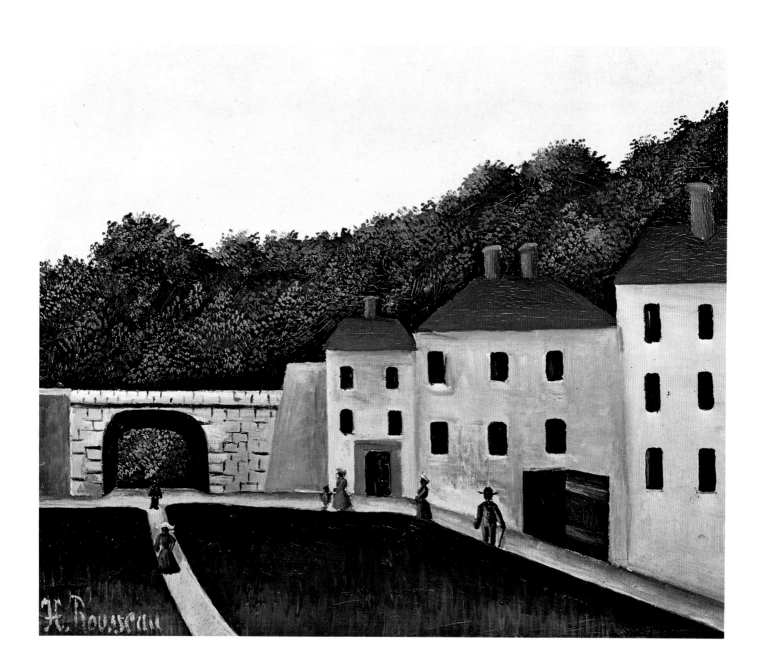

22) Landscape with Arch and Three Houses
1907–08 $18\frac{3}{8} \times 22''$

Collection Walter-Guillaume
Musées Nationaux, Paris

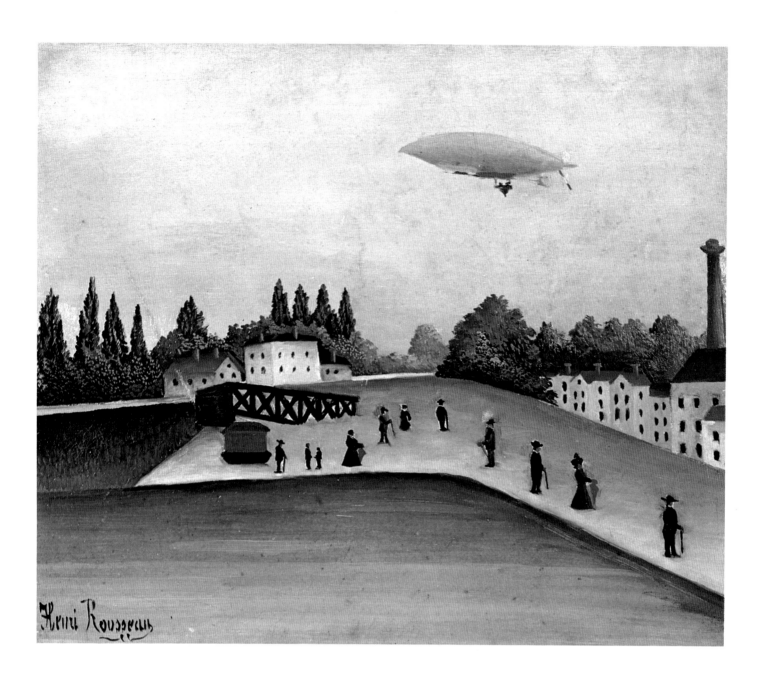

23) Landscape with Crane and the Zeppelin 'Patrie'
1907–08 18⅜ × 21¾″
Ishibashi Collection, Tokyo
Photo – Held/Ziolo

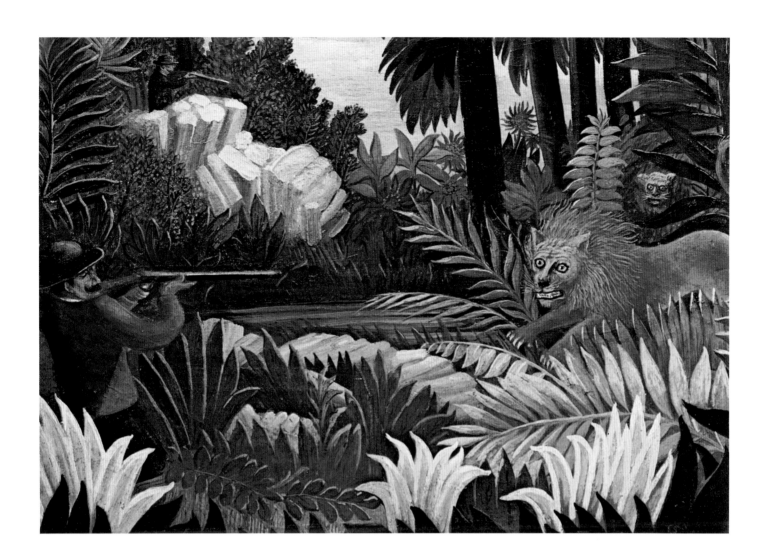

24) La Chasse au Lion
1900–07 18 × 21½″
Private Collection, Paris
Photo – X/Ziolo

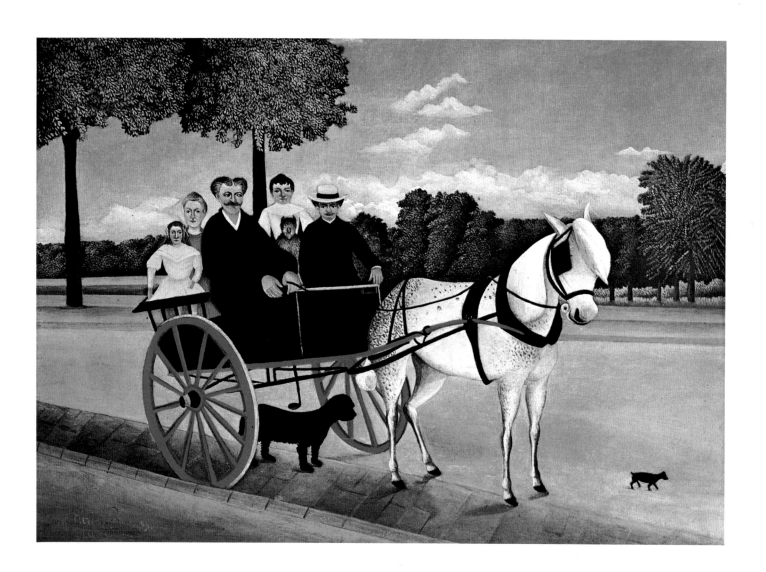

25) La Charrette du Père Juniet
1908 38¾ × 51½″

Collection Walter-Guillaume
Musées Nationaux, Paris
Photo – Scala

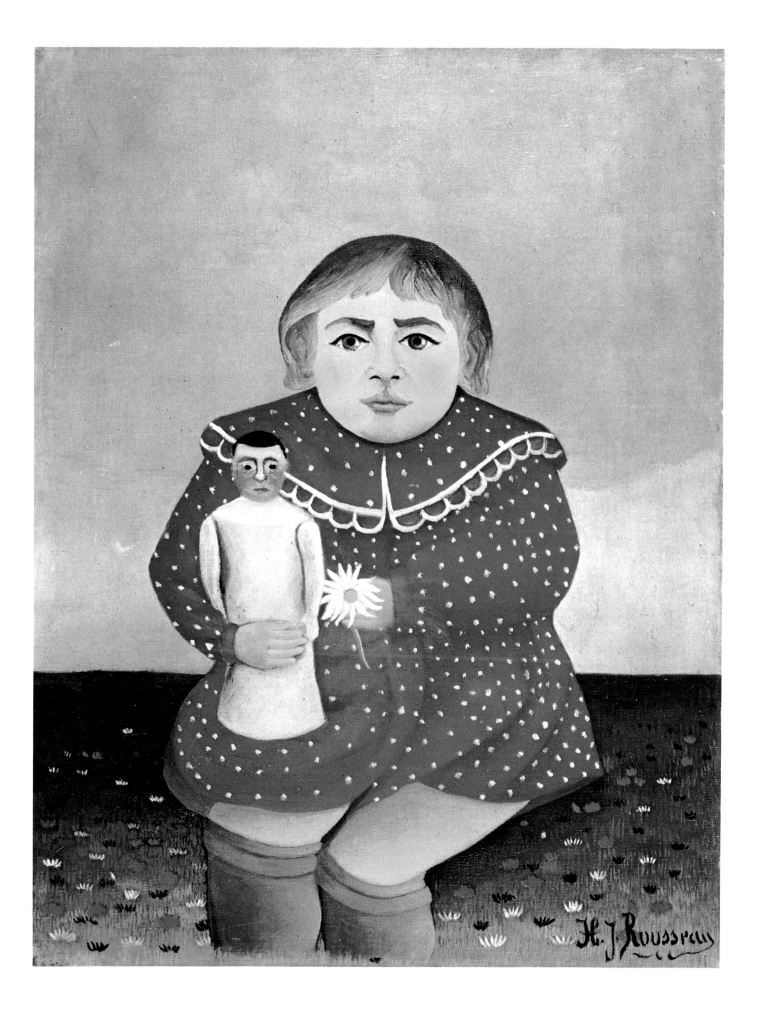

26) Child with Doll
1908 26¾ × 20¾″

Collection Walter Guillaume
Musées Nationaux, Paris
Photo – Roland/Ziolo

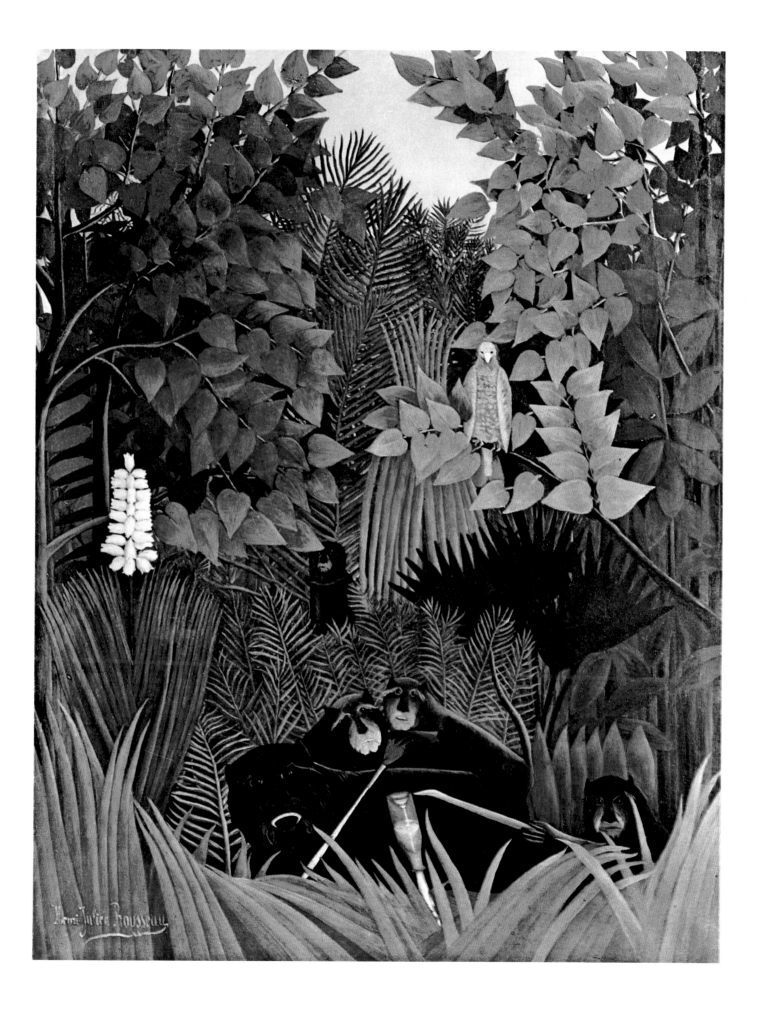

27) The Merry Jesters

1906 $57\frac{3}{8} \times 44\frac{5}{8}''$

Louise and Walter Arensberg Collection
Philadelphia Museum of Art, Pennsylvania

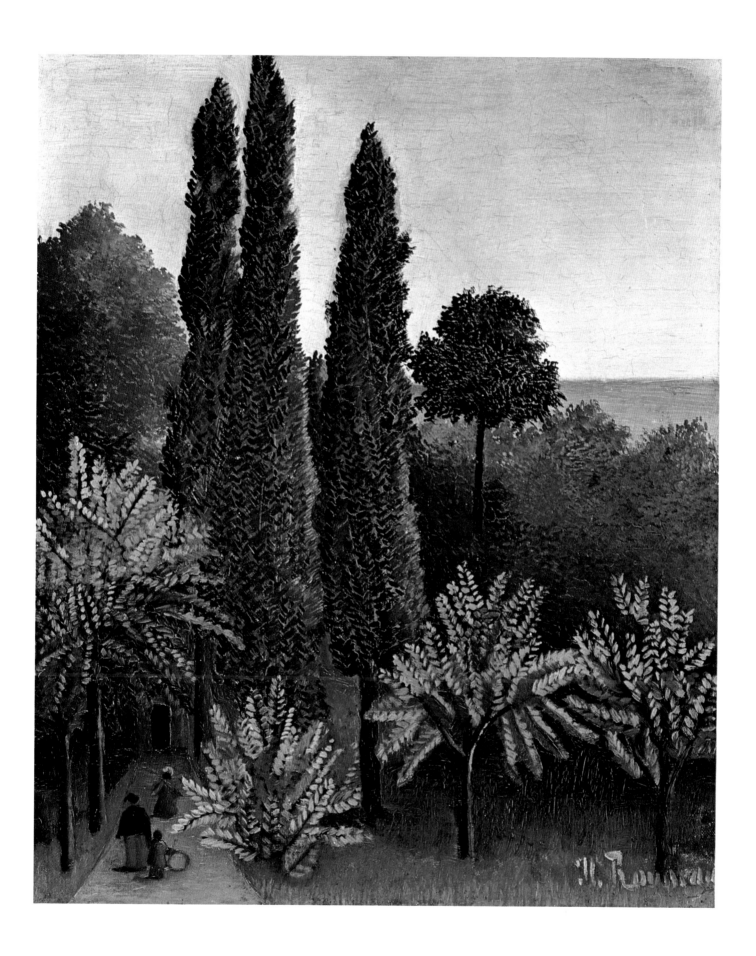

28) Allée dans le Parc des Buttes Chaumont
1908 $18\frac{3}{8} \times 15\frac{1}{2}''$

Private Collection, Paris
Photo – Roland/Ziolo

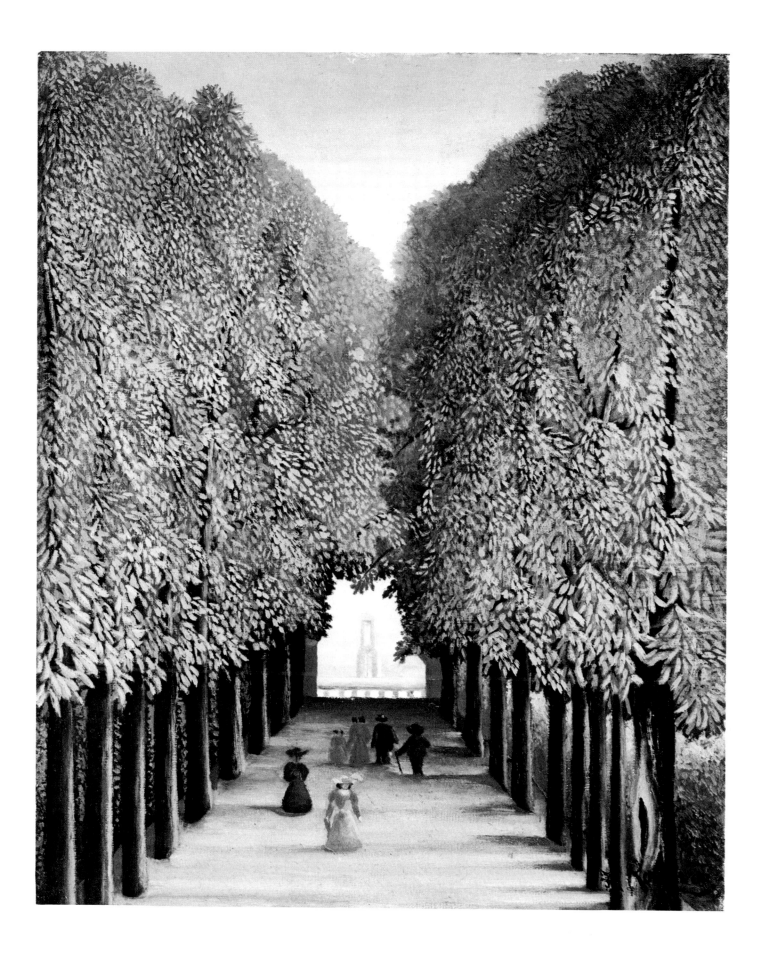

29) Allée dans le Parc de Saint Cloud
1908 $18\frac{3}{8} \times 15\frac{1}{4}''$

Städelsches Kunstinstitut, Frankfurt
Photo – Blauel

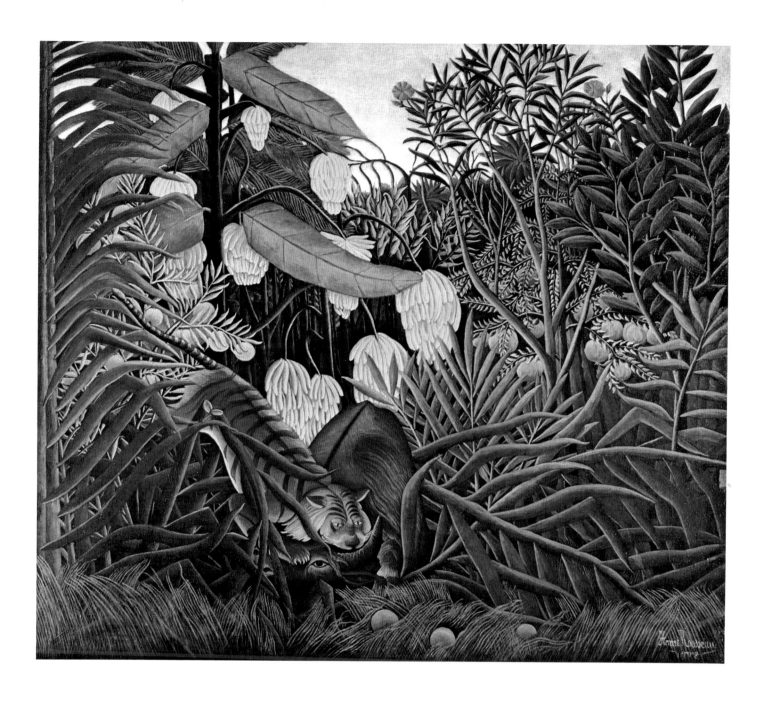

30) Tiger Attacking a Buffalo
1908 $68\frac{3}{4} \times 76\frac{3}{8}''$
Museum of Art, Cleveland

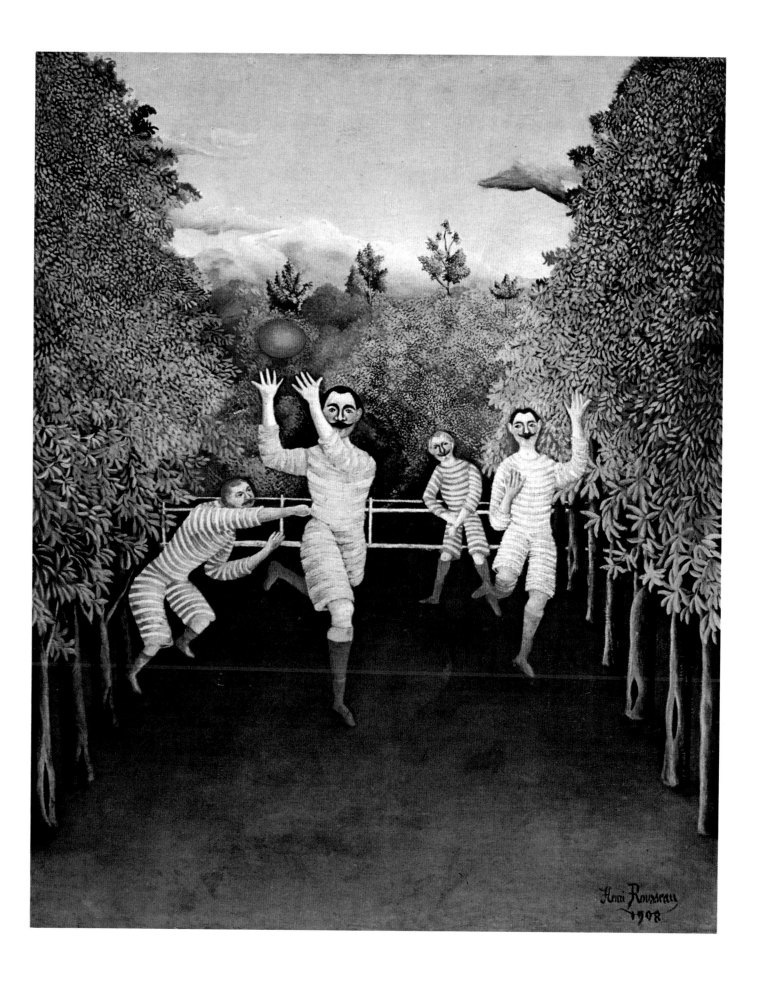

31) Football Players
1908 $39\frac{1}{2} \times 31\frac{5}{8}''$
The Salomon R. Guggenheim Museum, New York

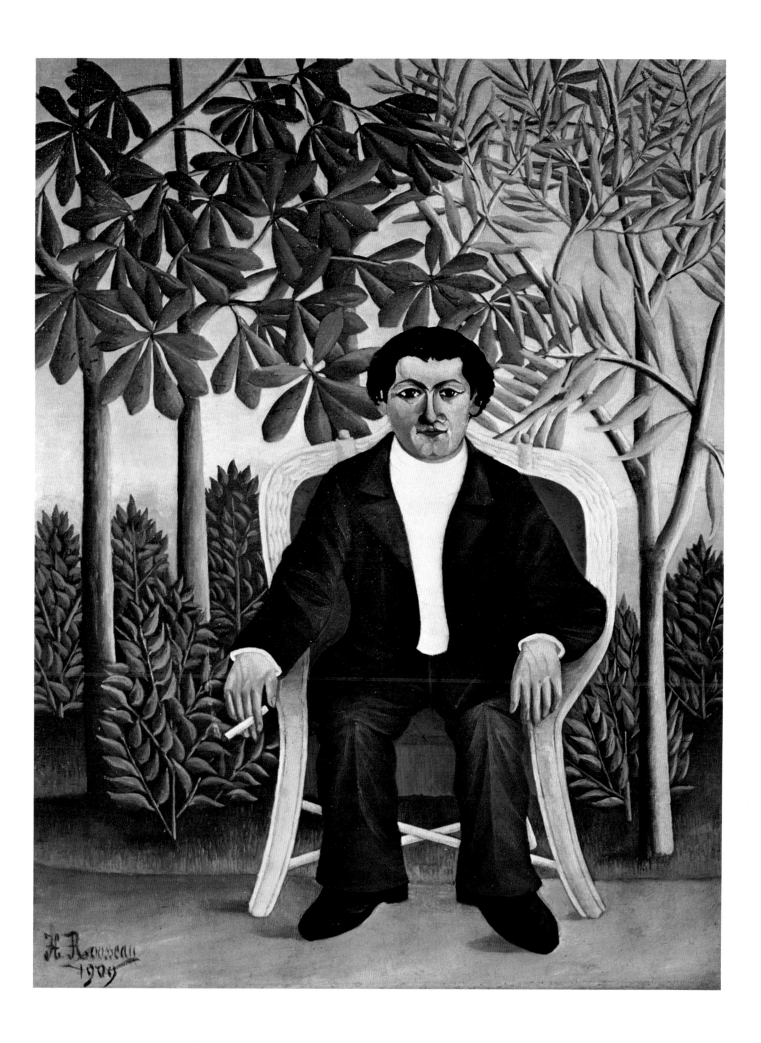

32) Portrait of Joseph Brummer

1909 $46\frac{3}{4} \times 34\frac{3}{4}''$

Kunstmuseum, Basle
Photo – Hinz

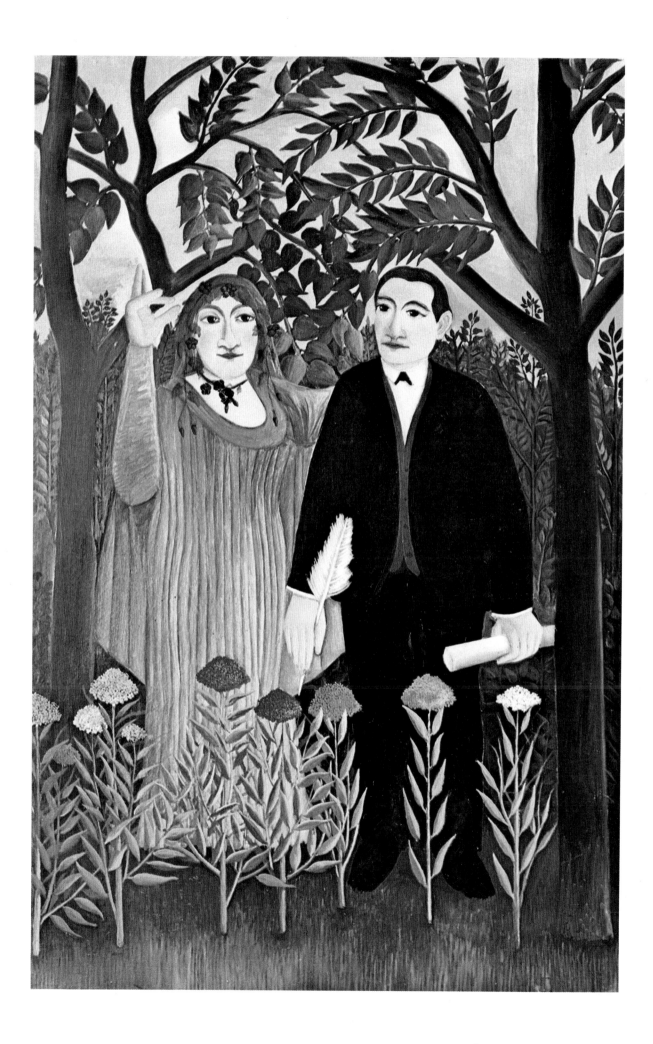

33) La Muse Inspirant le Poète
1909 $38\frac{3}{4} \times 58\frac{3}{4}''$

Kunstmuseum, Basle
Photo – Hinz

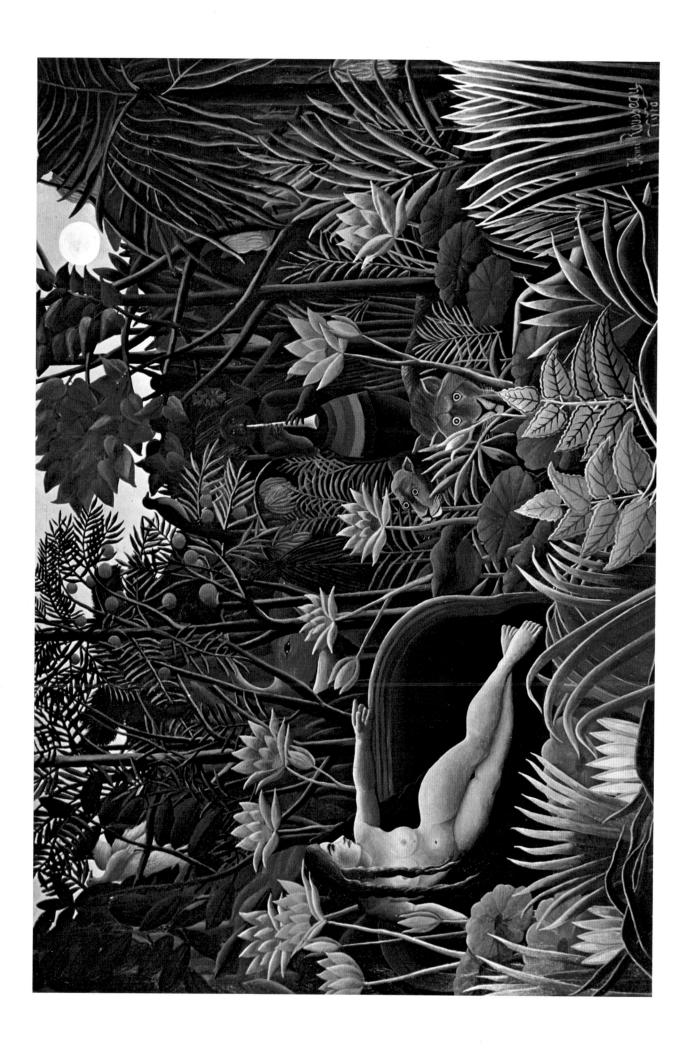

34) The Dream
1910 $81\frac{3}{4} \times 119\frac{1}{2}''$
Museum of Modern Art, New York

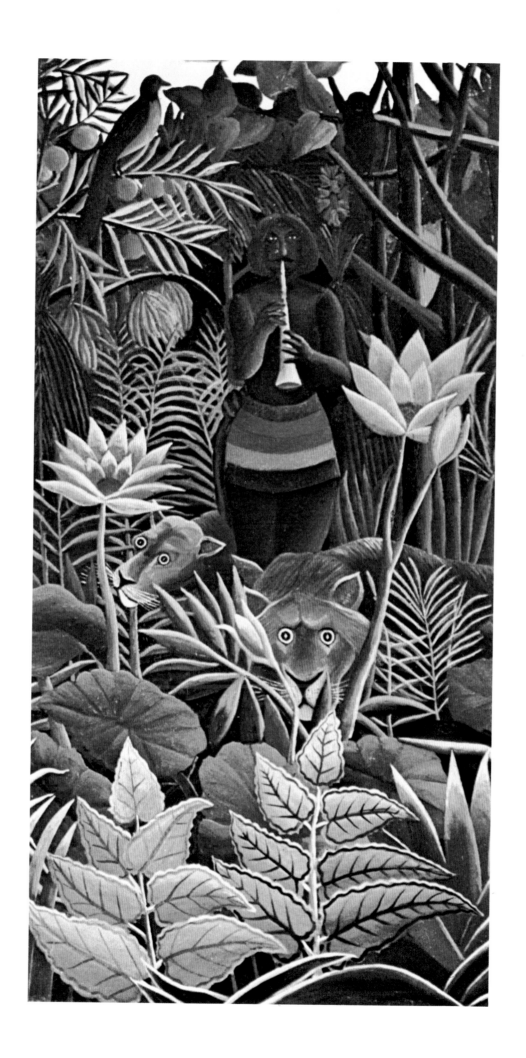

35) From
The Dream
1910 $81\frac{3}{4} \times 119\frac{1}{2}''$
Museum of Modern Art, New York

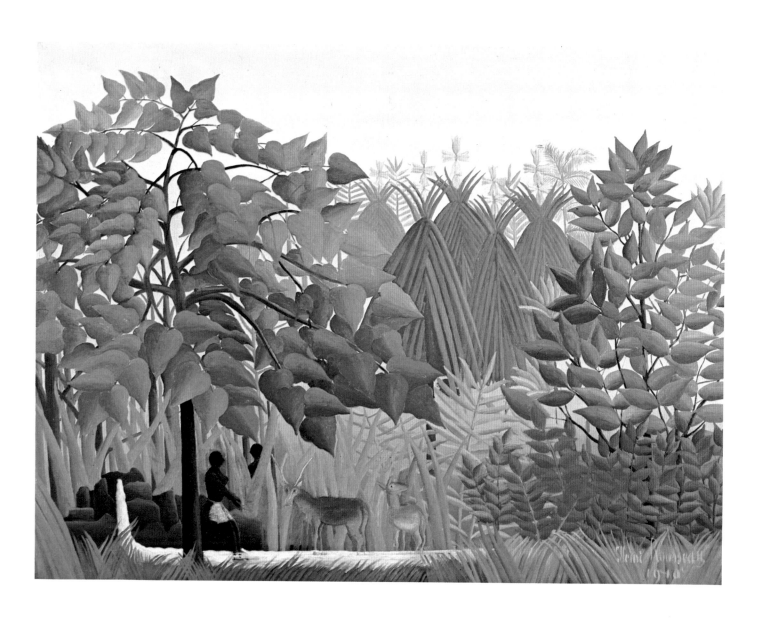

36) The Waterfall
1910 45⅝×59″
Art Institute, Chicago

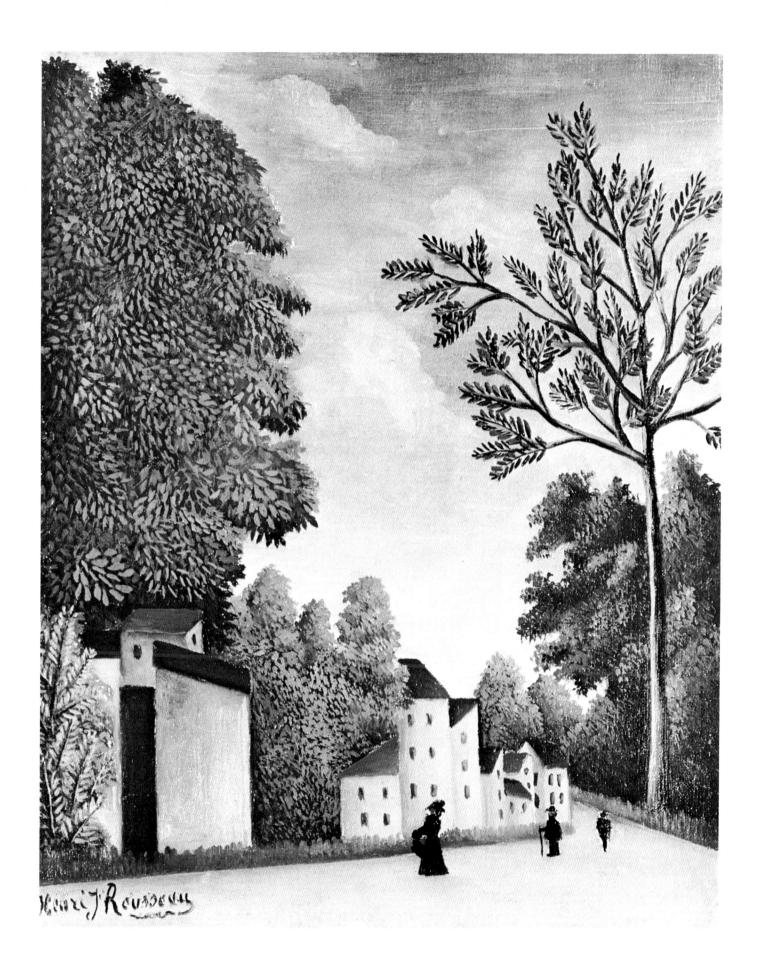

37) Village Street

1910 $16\frac{3}{8} \times 13\frac{1}{4}''$

Philadelphia Museum of Art, Pennsylvania

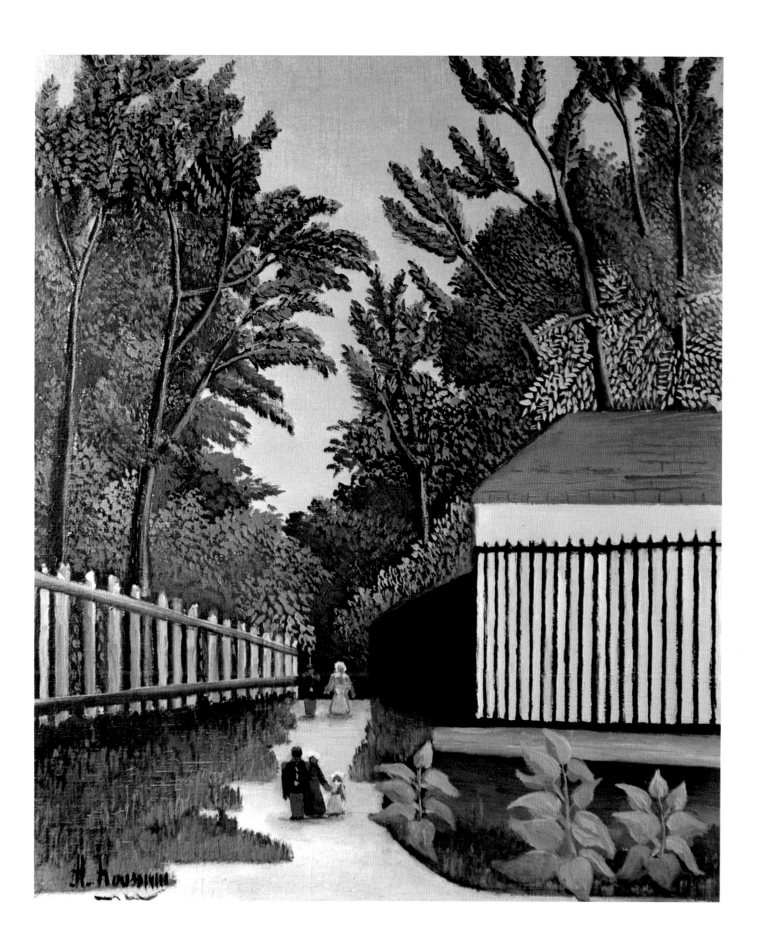

38) Vue du Parc Montsouris
1910 $18\frac{3}{8} \times 15\frac{1}{4}''$

Pushkin Museum, Moscow
Photo – APN

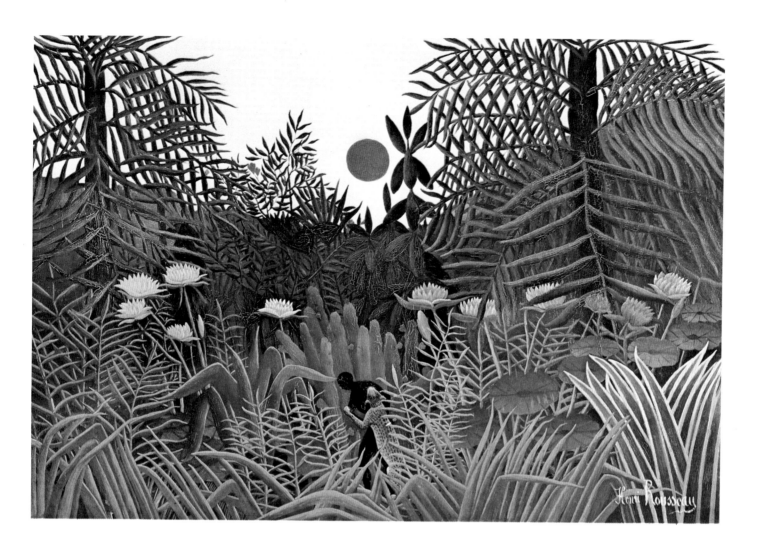

39) Jungle at Sunset with Attack
1910 $57\frac{1}{2} \times 65''$
Kunstmuseum, Basle
Photo – Hinz

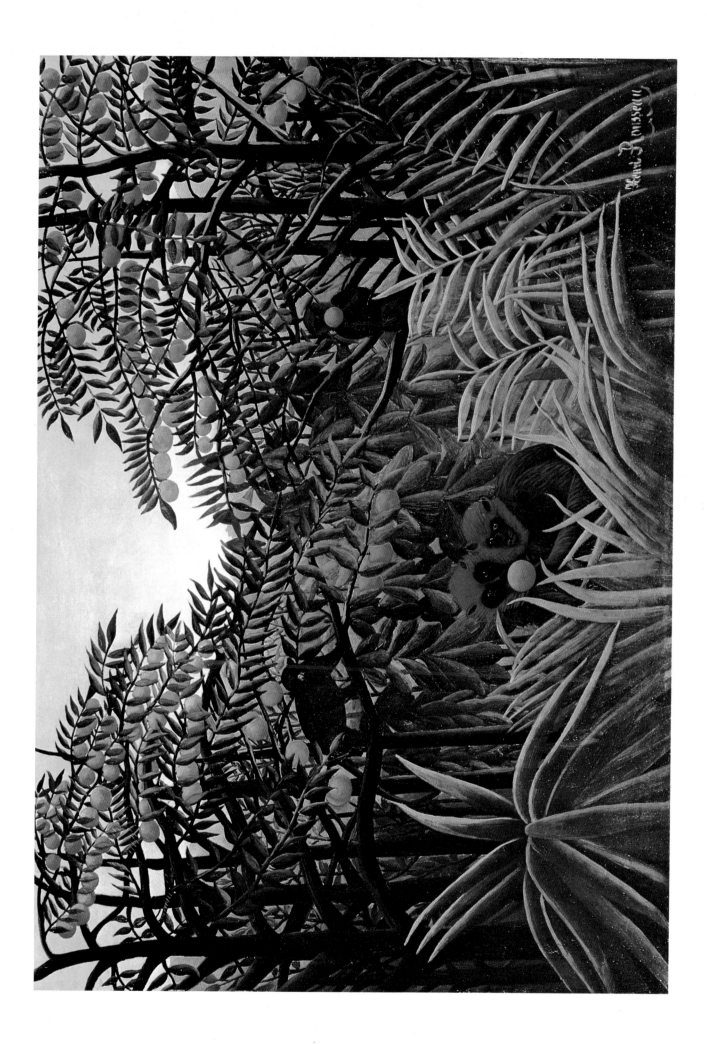

40) Jungle with Monkeys
1910 $44\frac{3}{8} \times 64\frac{3}{4}''$
Metropolitan Museum of Art, New York